D1199318

REMEMBERING
NOTRE DAME
PART II: Living and Learning

Michael D. Ciletti '64, '65, '68

REMEMBERING NOTRE DAME
Part II: Living and Learning

Copyright © 2013 Michael D. Ciletti

ISBN 978-0-9890731-4-1

ACKNOWLEDGMENT: The author is pleased to acknowledge the resource used for the historical information cited in this book: T.J. Schlereth, The University of Notre Dame: A Portrait of Its History and Campus, University of Notre Dame Press, 1976.

Prints of Images: Over four hundred images of the campus, including those presented in Remembering Notre Dame, may be ordered as individual prints in formats and sizes suitable for framing. See the web site: www.mdcimages.com for details.

Published by
Corby Books
A Division of Corby Publishing LP
P.O. Box 93
Notre Dame, Indiana 46556
(574) 784-3482
www.corbypublishing.com

Distributed by ACTA Publications, 4848 N. Clark Street, Chicago, IL 60640.
800-397-2282 ~ www.actapublications.com

Manufactured in the United States of America

Dedication

This book is dedicated to Fr. Theodore M. Hesburgh, C.S.C., President Emeritus of the University of Notre Dame. Fr. Hesburgh served the University as its president for 35 years. He inspired and oversaw unprecedented development of the University, transforming it from a all-male institution with a singular identity tied to football, to an integrated, co-educational university with an international identity in academics, athletics, and service. Football and athletics still hold sway at Notre Dame, but so do academic prowess, social concerns and out-reach to the world. Notre Dame connects to the old-world intellectual tradition of a Catholic University, but brings to it a post Vatican-II commitment to being leaven in the world. Its students emerge with preparation to help serve the poor and oppressed.

About the Author

Mike Ciletti, of Colorado Springs, CO, graduated from Notre Dame with degrees in electrical engineering (1964, 65, 68). A "Triple Domer," he has had a lifelong love for the university, and is grateful for the people of Notre Dame who have blessed and shaped his life. Mike and his wife Jerilynn have five children and twelve grandchildren.

About the Images

All images are originals, captured in raw format with Nikon D300, D700, and D800e cameras and post-processed with Nikon Capture NX2 and related software. In some cases images are a composite of multiple but differently exposed images to better approximate the lighting experienced by the human eye, and processed for artistic expression and impact.

Introduction

The Golden Dome captures the attention of all who come to Notre Dame. Its iconic status sets it apart from all other campus sites. Thus, the first volume in the *Remembering Notre Dame* series highlighted its beauty and prominence. The campus has many other icons, large and small. Familiar sights and details of buildings and places on campus lay claim to chambers of our memories and hold the capacity to re-connect us to the times and places of our being part of Notre Dame.

This volume in the *Remembering Notre Dame* series presents images of two key elements of campus life: its residence halls and its instructional and research facilities (i.e., classrooms, and laboratories), the places where students live and learn. Residence halls are a distinctive feature of Notre Dame, with most students living on campus. Dorm residents form lifelong bonds of friendship. For each student, the campus lore is grounded in their experience of dorm living. The dormitories are the anchors and a point of reference for our remembering the friends made during those years of living on campus.

Perhaps the second-most recognizable contemporary iconic image of the campus is that of the Hesburgh Memorial Library and its huge mosaic of Christ: "The Word of Life." Championed by Fr. Hesburgh, the Library is the unmatched representation of the academic mission of the University.

Notre Dame's buildings for living and learning have developed significantly in the last fifty years. Certainly, some of the depression-era and earlier buildings continue to function, but with new tenants. The old workhorses of Nieuwland Science Hall, Cushing Hall of Engineering, the Biolchini Law Building, Hurley Commerce Building, and O'Shaughnessy Hall still function but in some cases have new roles. The old wing of Nieuwland Science Hall still stands, but now serves programs in the arts rather than organic chemistry. Gone are the tennis courts, faculty club, ROTC parade grounds and football parking lots south

of Cushing Engineering Building. In their place are the DeBartolo classroom building, the Mendoza College of Business, Stinson-Remick engineering building, the Hesburgh Center for International Studies, and the DeBartolo Performing Arts Center (DPAC). Nieuwland Science Hall is adjoined by Stepan Chemistry Hall. The Burke Memorial Golf Course is now a nine-hole course, with dormitories replacing fairways as the number of residence halls for undergraduate students has more than doubled since the 60s. The 18-hole Warren Golf Course, built at the northeast end of campus, now beckons golfers. Also, housing for graduate and married students has been developed.

Expansion of the University's physical plant has been strategic and coherent, with attention to preservation of a continuity to its past. This continuity is apparent in the architectural details of the modern era of construction, and serves as a visual framework for this book, and its presentation of the beauty of the campus.

May the images herein awaken in you fond memories of familiar places at Notre Dame. May they call attention to the details that beautify the buildings of the campus.

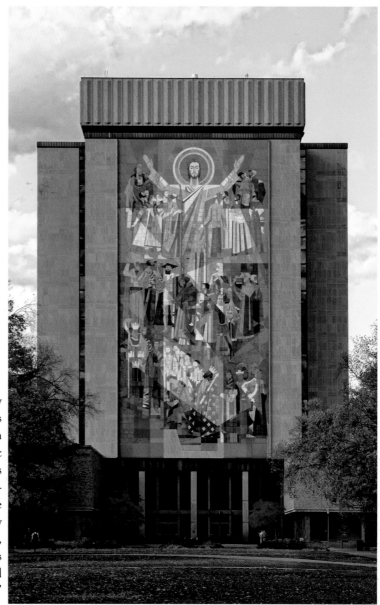

The Hesburgh Memorial Library is testimony to Fr. Hesburgh's guiding vision and inspiration in Notre Dame's quest for academic excellence. The face above its main entrance holds an expansive mosaic—the Word of Life mural. Its proximity and visibility from within the football stadium, especially from the press box, has led to its being commonly referred to as "Touchdown Jesus."

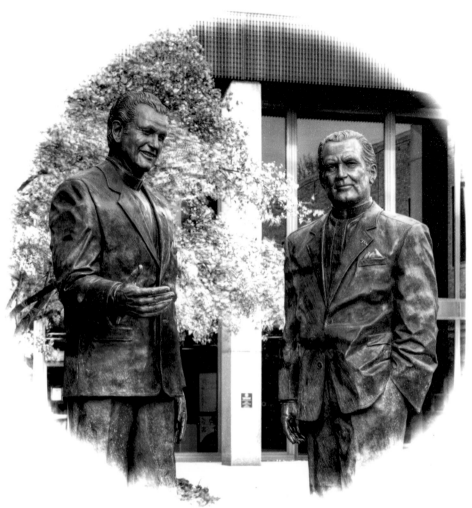

Fr. Theodore ("Ted") Hesburgh and Fr. Edmund ("Ned") Joyce served as president and executive vice president, respectively, for 35 years, guiding the University through unprecedented and transformational development. On their watch, the student body became co-educational and the physical plant expanded with several new dormitories, laboratories, classroom buildings, a library, a performing arts center, and enlargement of the football stadium. In addition, the endowment grew to establish a secure financial future for the University.

At the west side of the Library stands Josip Turkalj's larger-than-life scupture Moses, holding tablets with the Ten Commandments and pointing to the sky. Turkalj was a native of Croatia and came to the university as a young assistant to Ivan Mestrovic. Both of them would have been more versed in European football (soccer) than American football; nonetheless, this sculpture of Moses has come to be called "First-down Moses" or sometimes "#1 Moses."

Panels on the walls of the Library present biblical themes. Here: Fish of the Living.

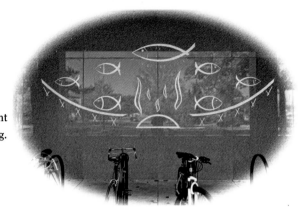

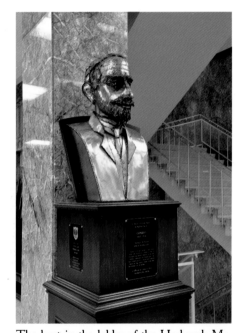

The bust in the lobby of the Hesburgh Memorial Library reminds us that the name of the well-known author Joseph Conrad (Heart of Darkness) is actually Teodor Jósef Konrad Korzeniowski. The plaque notes that he "thought in Polish, wrote in English."

As mid-semester exams approach, and when dorms are noisy, the Library provides a place of refuge for grade-conscious students.

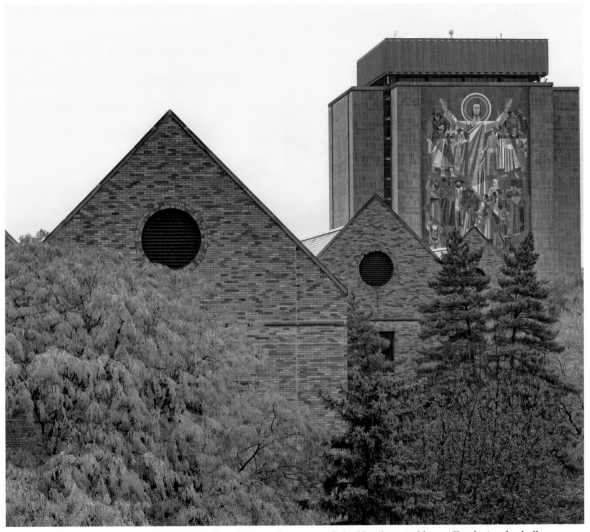

The upper concourse of the football stadium is where you will find hotdogs and hot coffee during football games. It also offers a special view of Decio Faculty Hall and the Hesburgh Memorial Library.

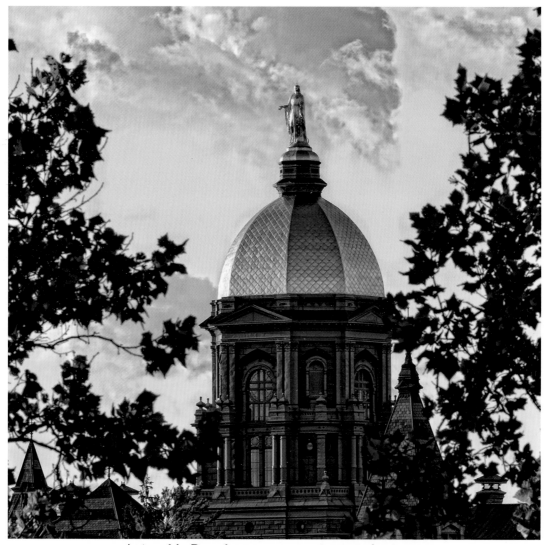

A view of the Dome from any vantage point graces the campus.

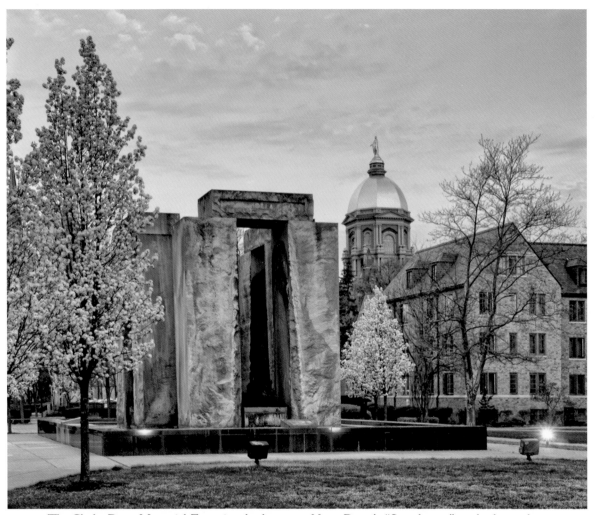

The Clarke Peace Memorial Fountain, also known as Notre Dame's "Stonehenge," marks the southern edge of the North Quad, shown here with trees bearing spring blossoms. Students rest here during the warm days of spring and fall; cheering crowds gather here after memorable football victories to enjoy the spray of the fountain. Sometimes, mysteriously, on those occasions the water turns shamrock green.

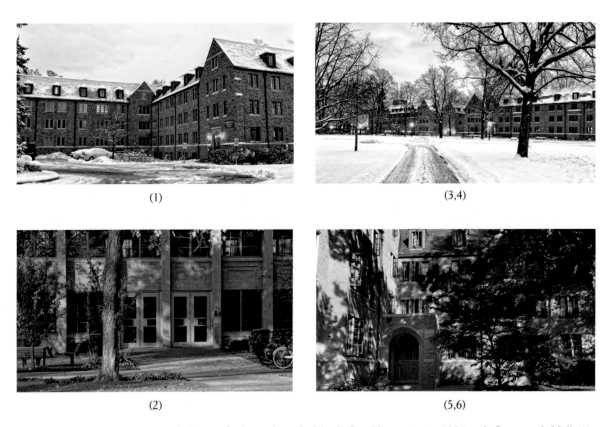

(1)

(3,4)

(2)

(5,6)

Residence halls were built in the Collegiate-Gothic style in the North Quad beginning in 1936 with Cavanaugh Hall (1), followed by Zahm (2), Farley (3), and Breen-Phillips Hall (4), the phase ending in 1942 with construction of Farley Hall. Zahm Hall, named after scientist and historian Fr. John A. Zahm, is a mirror-image twin and neighbor of Cavanaugh Hall. Keenan (5) and Stanford (6) halls, departing from the Collegiate-Gothic style and having a plain and functional appearance, were built in 1957 and share a common lobby and chapel.

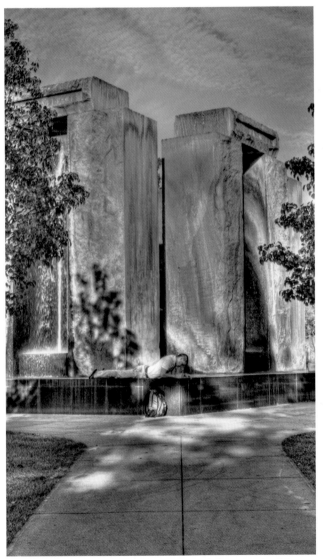

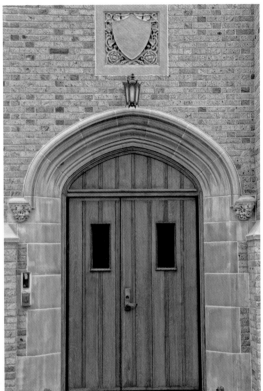

The stone work at an entrance to Farley Hall typifies the Collegiate-Gothic style which embellishes the older dormitories of the North Quad, though not as elaborately as those in the Depression-era South Quad. Farley Hall's namesake, Fr. John "Pop" Farley, who served as rector of Corby, Walsh, and Sorin halls, was known to have referred to his students as "my boys."

The peaceful sound of splashing water and the warmth of the sun make "Stonehenge" an ideal place to write a letter to a friend.

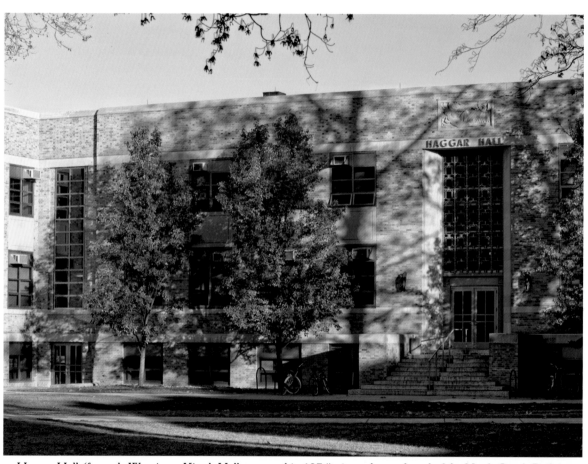

Haggar Hall (formerly Wenninger-Kirsch Hall, renamed in 1974) sits at the north end of the North Quad. Built in 1937, Haggar Hall houses Notre Dame's internationally recognized program in germ-free research in bacteriology.

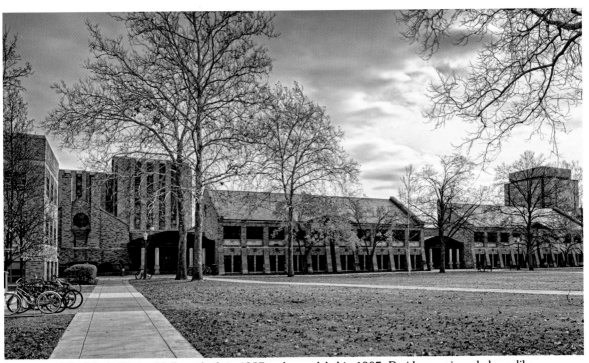

The North Dining Hall was built in 1957 and remodeled in 1987. Besides creating a balcony-like second level for dining, the remodeling marked a change from a fixed line of food service with minimal choices to an open food court with seemingly unlimited selections.

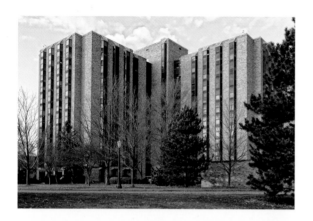
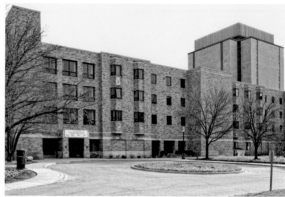

In 1969, on grounds once occupied, in part, by Vetville, the University erected two high-rise towers, Grace Hall (shown here) and Flanner Hall, in what was to become the Memorial Library Quad, immediately north of the Library. In the mid-1990s, when the Main Building was closed for renovation, these two buildings were converted into administrative offices. The site has since been developed further with four additional residence halls: Pasquerilla West, Pasquerilla East, Knott, and Siegfried halls.

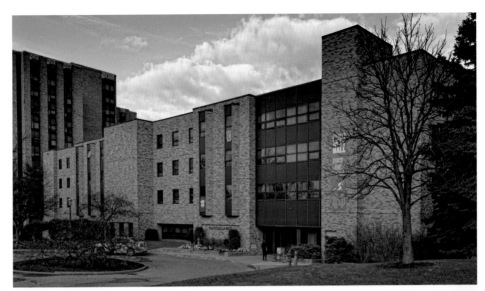

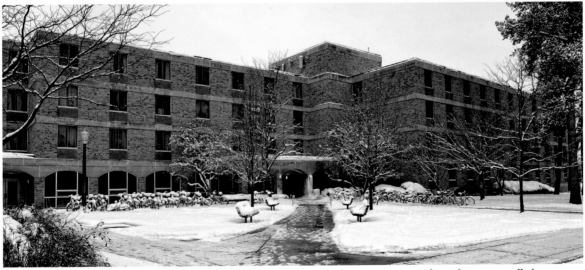

Pasquerilla West Hall and Lewis Hall – Lewis Hall was built to serve as a residence for nuns enrolled in summer school, but is now a dormitory for women. Sitting in the shadow of the Dome, it is somewhat isolated from the other dorms, but its residents enjoy a view of St. Joseph's Lake.

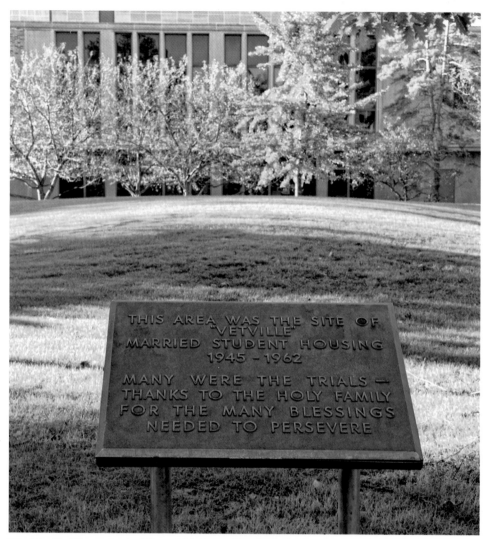

THIS AREA WAS THE SITE OF
"VETVILLE"
MARRIED STUDENT HOUSING
1945 - 1962

MANY WERE THE TRIALS —
THANKS TO THE HOLY FAMILY
FOR THE MANY BLESSINGS
NEEDED TO PERSEVERE

The Vetville Plaque (in the Memorial Library Quad) marks the site where housing was assembled for married students immediately after World War II. The housing consisted of prisoner-of-war barracks moved to the campus from Missouri. The units were demolished in 1961 to make room for the Library and to allow further expansion of the campus.

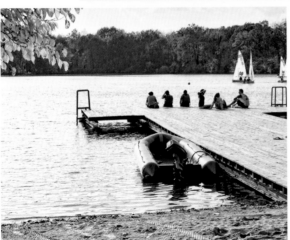

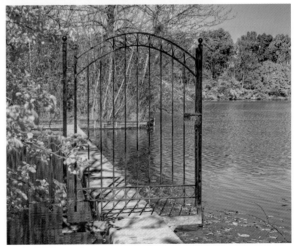

Runners and walkers use the path circling St. Joseph's Lake year-round, but it is especially inviting in the spring and fall. Notre Dame's sailing club uses the lake for its practices. A small island in the lake is off limits, but explorers manage to get around the gate near Lewis Hall.

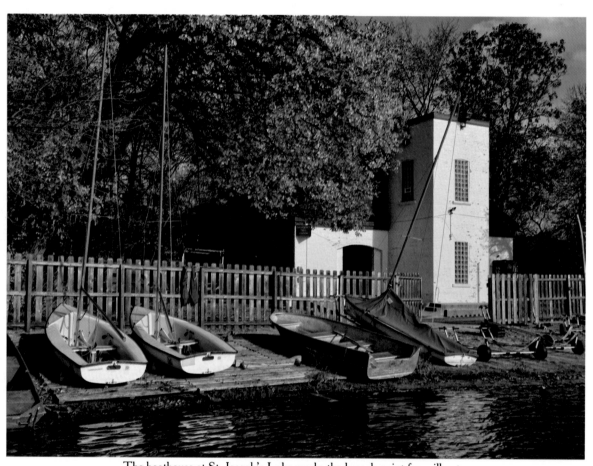

The boathouse at St. Joseph's Lake marks the launch point for sailboats.

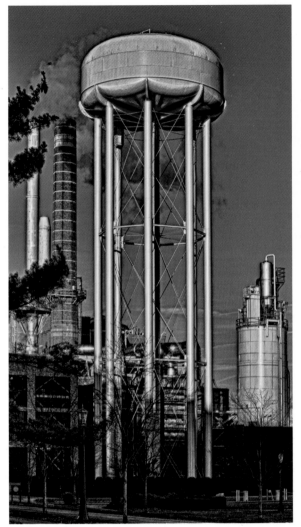

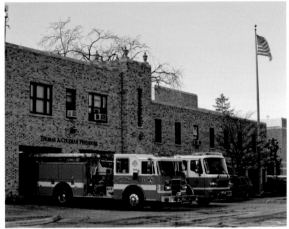

The campus water tower and power plant sit by St. Joseph's Lake, and dominate the skyline viewed from the North Quad. The University generates its own electricity and draws water from its own wells. Fire destroyed the Main Building in 1879; today the campus fire station sits near the power plant, houses modern equipment, and is staffed by professional firefighters.

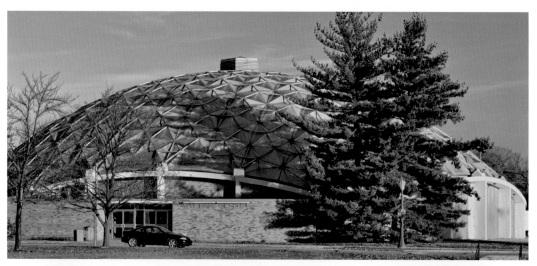

The Stepan Center, an all-purpose geodesic dome built in 1962, signaled increased attention to social life on campus. Dances, pep rallies, proms and other events were held here. In recent years, use of this facility has declined as larger and more functional social venues were built. Nearby are the Fischer and O'Hara-Grace Graduate Residences and the Wilson Commons (shown here) for graduate students.

Each fall the fields next to Stepan Center, known as "Riehle Playing Fields," get heavy use from band tryouts, interhall football, and other informal sporting events. Fr. Riehle, C.S.C., served the University in many capacities related to student life and athletics.

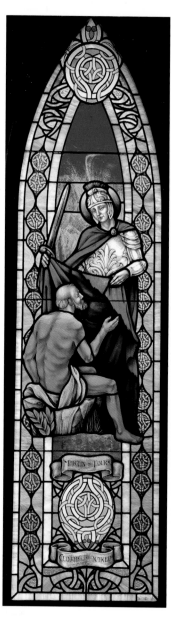

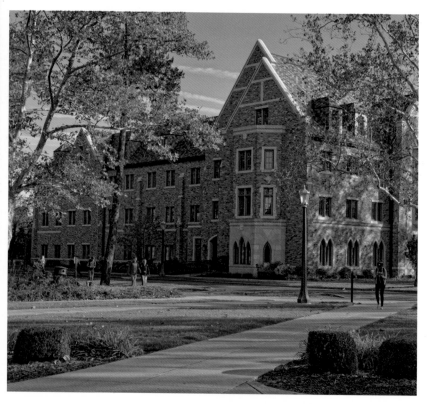

Located between the "Stonehenge" fountain and the west entrance to the Library, Geddes Hall houses Notre Dame's Center for Social Concerns. A stained-glass window in the hall chapel depicts the Roman centurion giving away his cloak—a theme linked to the University's thrust for social action and concern for the poor.

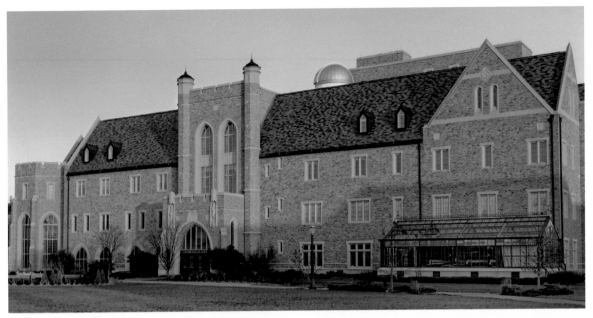

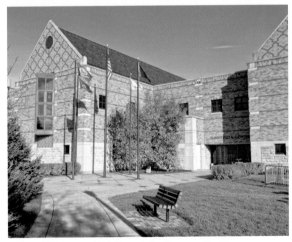

Jordan Hall of Science (in early morning light), the Ricci Band Rehearsal Hall, and the Pasquerilla Center (ROTC) are sited on the east side of the Library and what used to be Juniper Road.

The quad in front of the Hesburgh Memorial Library is flanked by the Information Technology Center (which housed a state-of-the-art Univac 1107 computer in the '60s), Decio Faculty Hall, Galvin Life Sciences Center, the Radiation Research Building, and Malloy Hall (Chapel shown here).

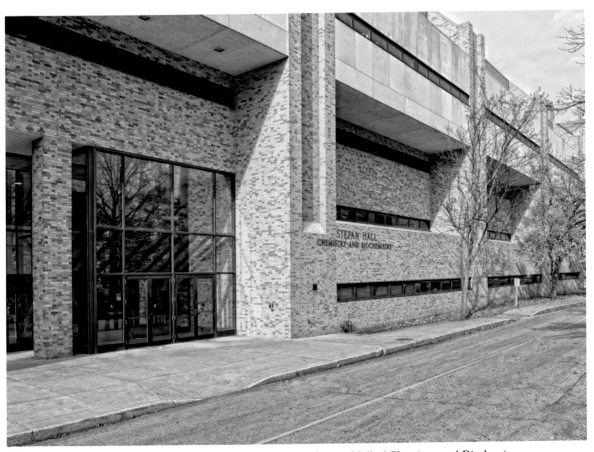

With an entrance that is off the well-traveled paths, Stepan Hall of Chemistry and Biochemistry is a major addition to the east side of Nieuwland Science Hall.

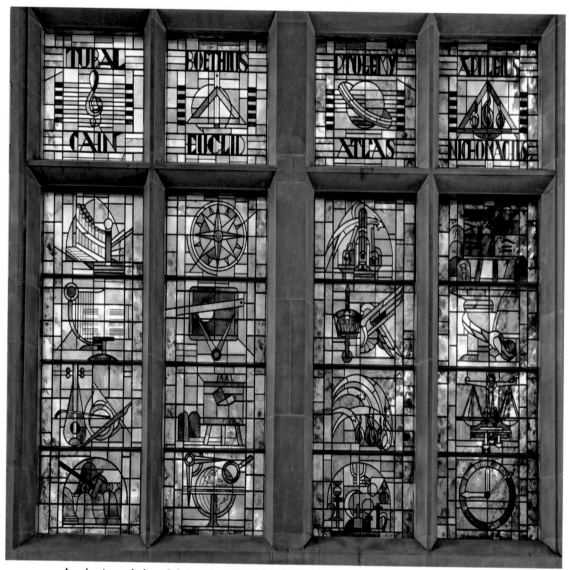

Academic symbols and the names of historic figures populate the stained-glass panels in the foyer of the main entrance to O'Shaughnessy Hall.

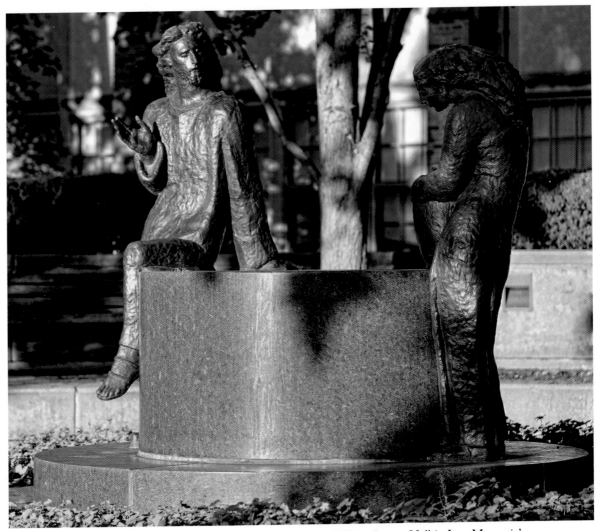

Truth, compassion, and forgiveness meet in front of O'Shaughnessy Hall in Ivan Mestrovic's Christ and the Samaritan Woman at the Well. Mestrovic created many of the major sculptures on campus.

27

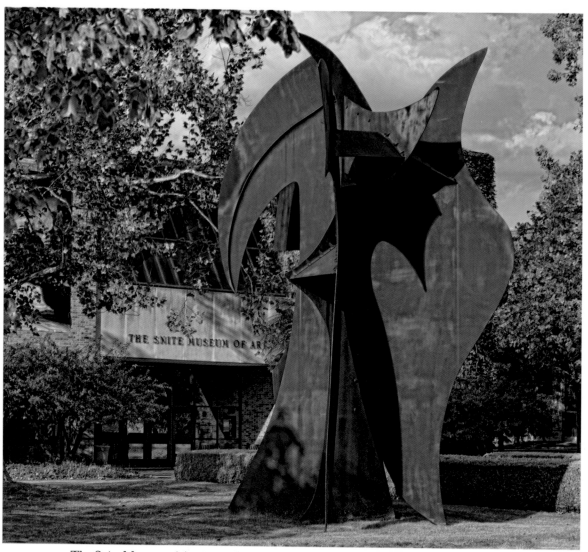

The Snite Museum of Art is attached to the south side of O'Shaughnessy Hall. It houses additional sculptures by Ivan Mestrovic, as well as other various collections of art. The gallery's Dillon Courtyard features two unusual kinetic sculptures.

Decio Faculty Hall sits behind O'Shaughnessy Hall and provides offices for a greatly expanded faculty in the College of Arts and Letters.

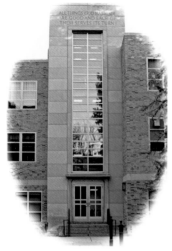

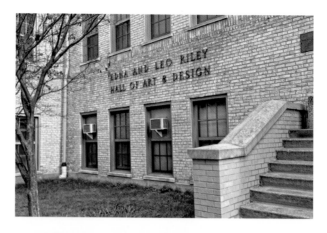

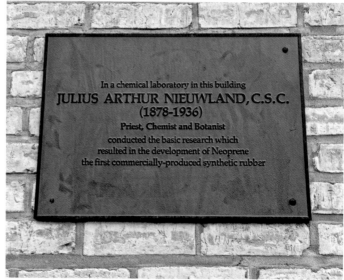

In a chemical laboratory in this building
JULIUS ARTHUR NIEUWLAND, C.S.C.
(1878-1936)
Priest, Chemist and Botanist
conducted the basic research which
resulted in the development of Neoprene
the first commercially-produced synthetic rubber

Between the God Quad (Main Quad) and the Library Quad we find the Nieuwland Science Hall, Crowley Hall of Music, and the Edna and Leo Riley Hall of Art and Design. Fr. Nieuwland's discovery of synthetic rubber occurred in the oldest part of the complex (now Riley Hall). Of note, Knute Rockne was a graduate assistant in Fr. Nieuwland's chemistry labs.

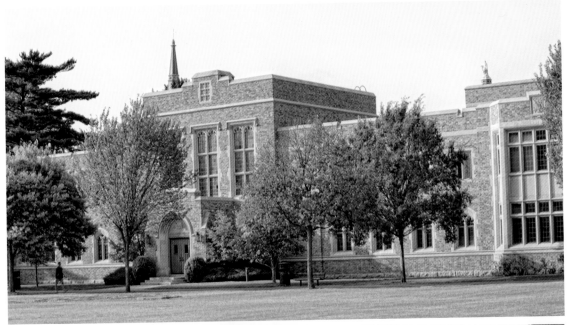

Hurley Hall housed the College of Commerce prior to construction of the Mendoza College of Business. If you are looking for the model of the ocean-going schooner that once capped the tower behind the main entrance to the building, you will find it in the courtyard of the Mendoza College of Business. We include, later, an image of a light-painting of the schooner. As symbols of the historical means for participating in worldwide commerce, the schooner partnered with the huge globe in the building's lobby, where it still remains. The building now serves the Department of Mathematics.

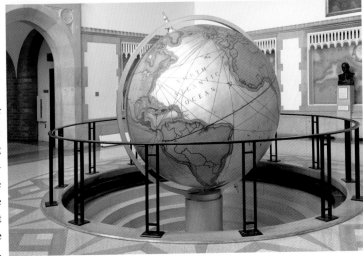

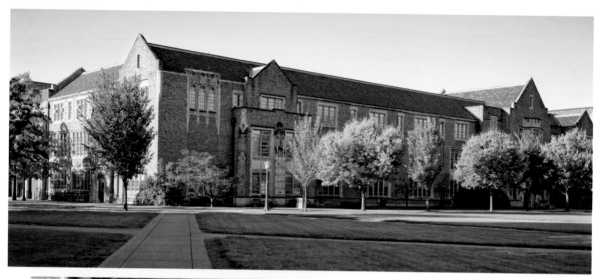

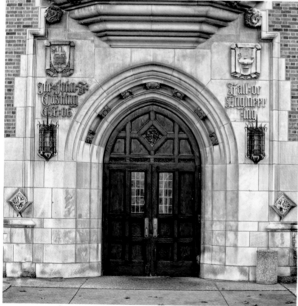

Cushing Hall of Engineering, built during the Great Depression and completed in 1933, is an iconic example of Collegiate-Gothic architecture replete with bas-relief sculptures.

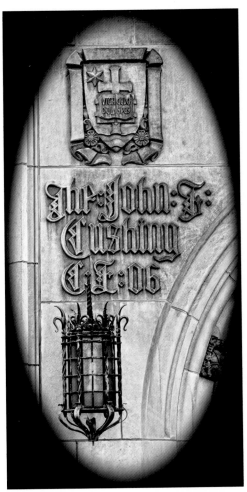

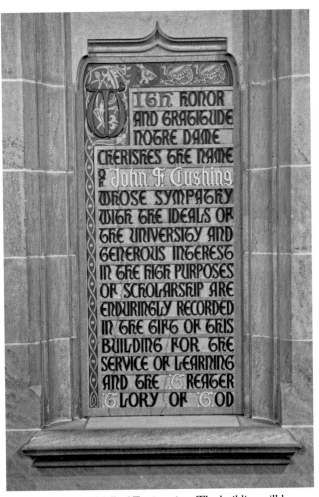

IN HONOR
AND GRATITUDE
NOTRE DAME
CHERISHES THE NAME
OF John F. Cushing
WHOSE SYMPATHY
WITH THE IDEALS OF
THE UNIVERSITY AND
GENEROUS INTEREST
IN THE HIGH PURPOSES
OF SCHOLARSHIP ARE
ENDURINGLY RECORDED
IN THE GIFT OF THIS
BUILDING FOR THE
SERVICE OF LEARNING
AND THE GREATER
GLORY OF GOD

Ornate relief work decorates the main entrance to the John F. Cushing Hall of Engineering. The building still houses offices, classrooms, and engineering labs. This is a must-see site for viewing period relief that depicts stereotypes of engineers presented in a cartoonish fashion. A plaque in the lobby of Cushing Hall honors the donor, John F. Cushing.

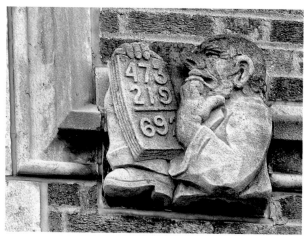

Near the roofline at the east side of Cushing Hall you will find two characters portraying engineers of the Depression era. One is startled by the text (grades?), and the other is practicing his arithmetic.

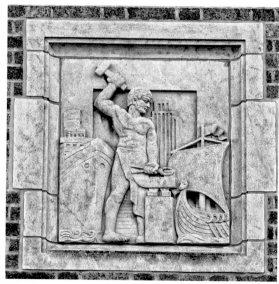

The engineer as builder is presented in relief on the north face of Cushing Hall.

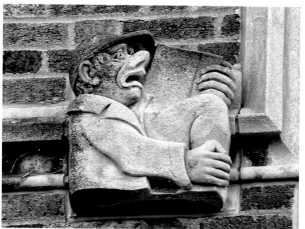

This engineer knows his math. Maybe he'll progress to calculus.

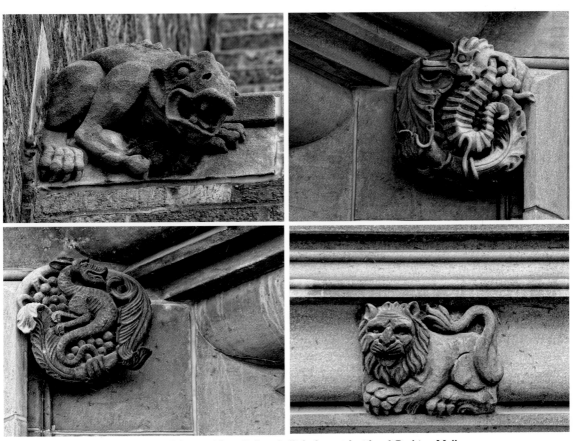

A variety of dragon-like reliefs embellish the north side of Cushing Hall.

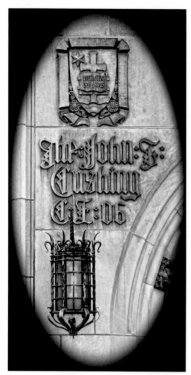

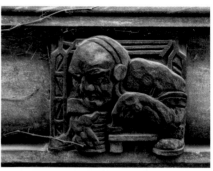

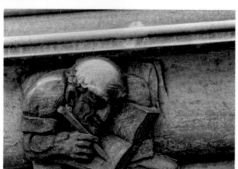

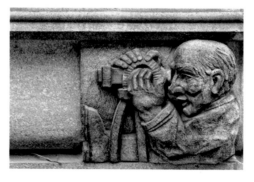

These reliefs are immediately above the main entrance to Cushing Hall. The Morse-Code key operator is a favorite of electrical engineers, though outnumbered here by civil engineers. Downspouts are monogrammed too.

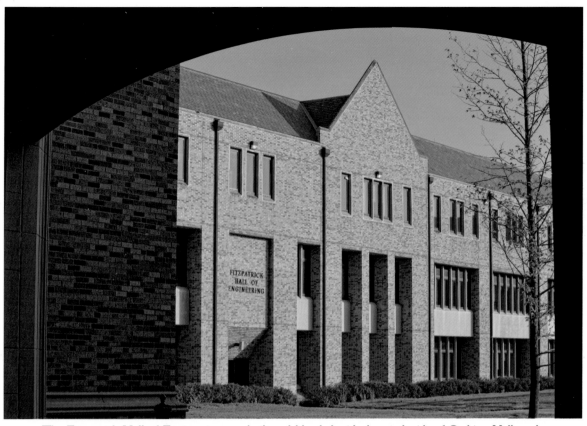

The Fitzpatrick Hall of Engineering was built and blended with the south side of Cushing Hall, and dedicated in 1979. It faces the DeBartolo Quad and the DeBartolo Performing Arts Center. Two floors of the structure are below ground level.

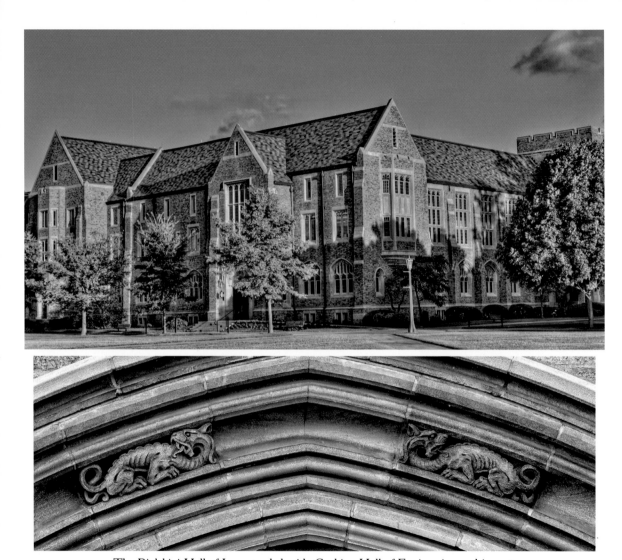

The Biolchini Hall of Law stands beside Cushing Hall of Engineering and is next to the Circle. Here we see dragons crouching above a window arch. In the hustle and bustle of going to and coming from class, students and others going by the Law School might not notice these creatures and other decorative reliefs.

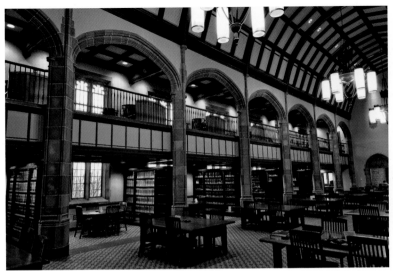

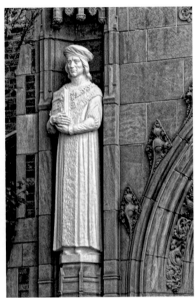

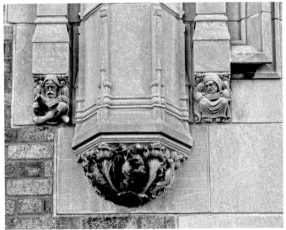

Library – Biolchini Hall of Law. A statue of St. Thomas More can be found beside the entrance arch at the west side of the building. Don't miss the figures at the base of the pedestal.

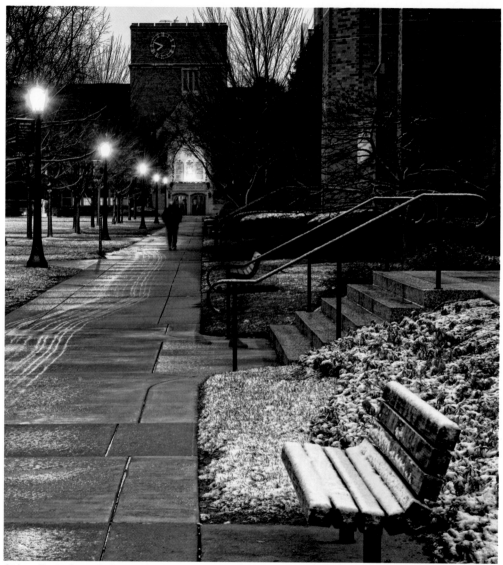

Sidewalks in the early hours of cold winter mornings are nearly deserted, but student-athletes can be found going to their workouts.

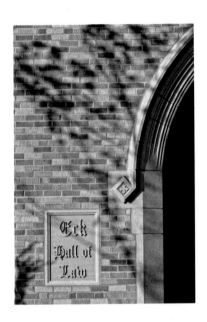

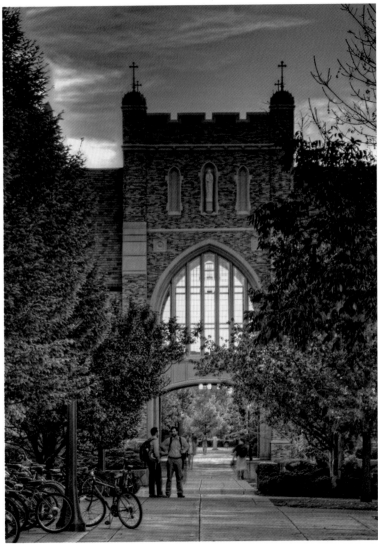

The arch connecting the Eck Hall of
Law and the Biolchini Hall of Law
forms a classical Collegiate-Gothic
structure; a snack bar and lounge oc-
cupy the room above the arch. Fans line
the sidewalk here to watch the band
march by en route to football games.

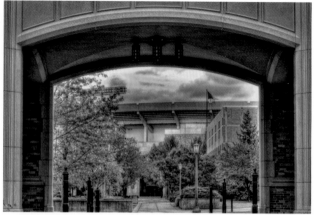

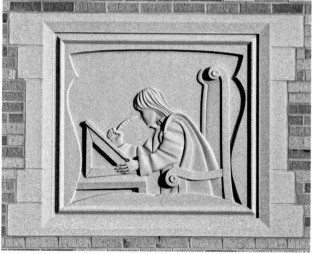

42 Sleek bas-reliefs decorate the Eck Hall of Law.

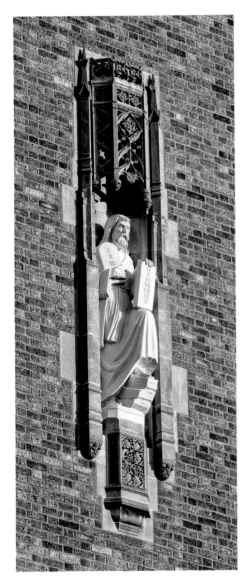

The Decalogue – Biolchini Hall of Law; Chapel – Eck Hall of Law

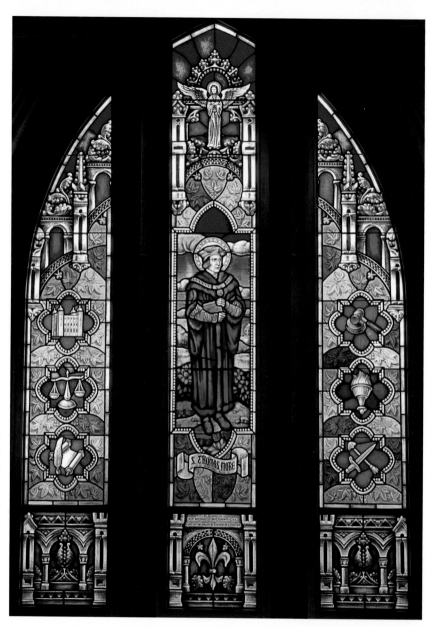

St. Thomas More—put to death by King Henry VIII—is the patron saint of lawyers. The saint is depicted in a major stained-glass window in the chapel of the Eck Hall of Law.

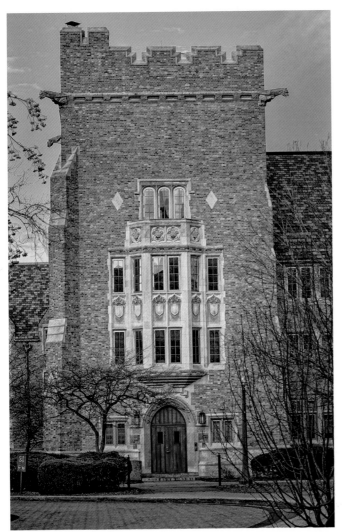

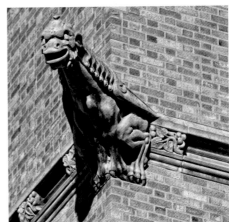

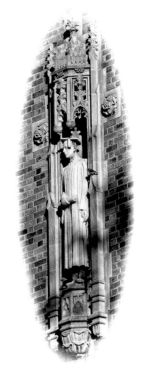

The residence halls of the South Quad are located west of "The Circle" at the entrance to the campus. Alumni Hall is the proud Collegiate-Gothic guardian of the Circle.

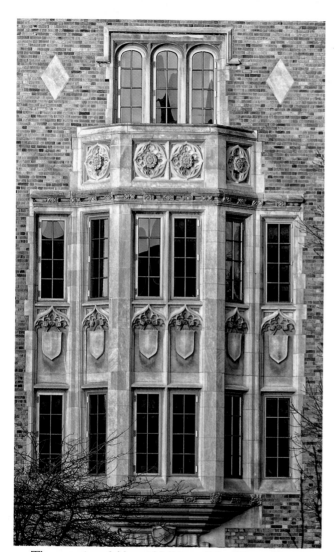

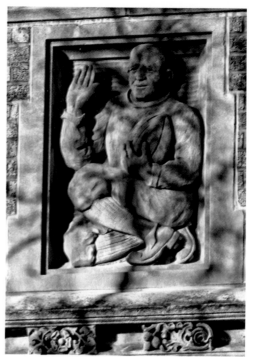

The east wing of Alumni Hall has reliefs of Knute Rockne, students, and the now-retired mascot, Clashmore Mike, an Irish terrier. Clashmore Mike was the mascot until, according to urban legend, it behaved inappropriately at a football practice directed by then-Coach Ara Parseghian. The leprechaun has reigned since then.

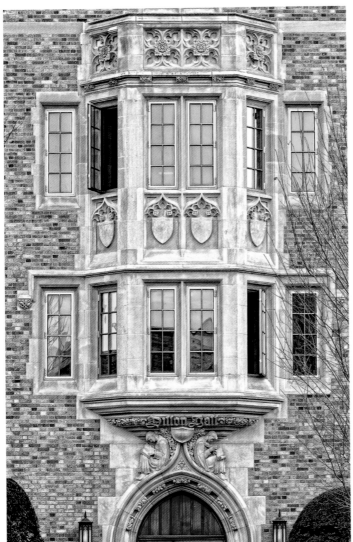

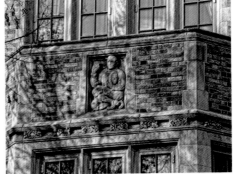

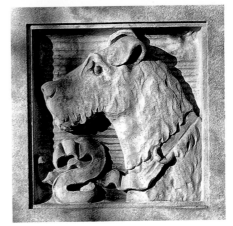

The entrance of Alumni Hall facing the Main Quad has bas-relief figures depicting students doing what students do — studying. Knute Rockne and Clashmore Mike reside in bas-relief on the east side of Alumni Hall.

The bay window above the north entrance of Alumni Hall is flanked by a pair of bas-reliefs in the Collegiate-gothic style.

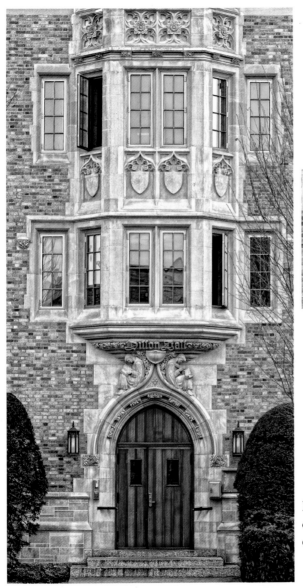

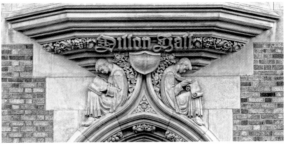

Dillon Hall is the neighbor and architectural companion of Alumni Hall, likewise richly decorated in the Collegiate-Gothic style.

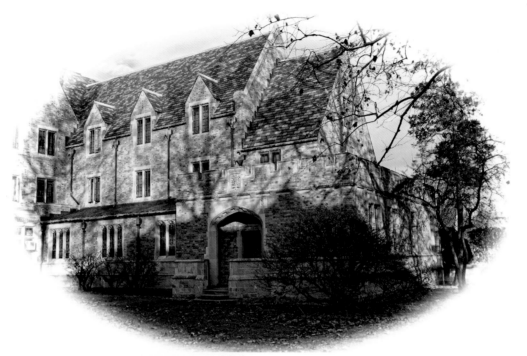

The "Chapel wing" of Dillon Hall borders a small courtyard that it shares with Alumni Hall.
The hall's main entrance, however, faces the South Quad.

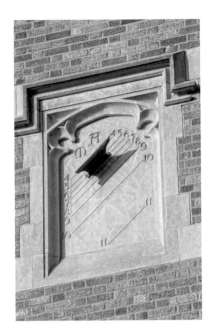

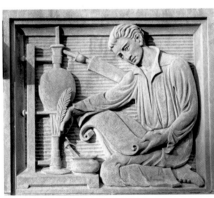

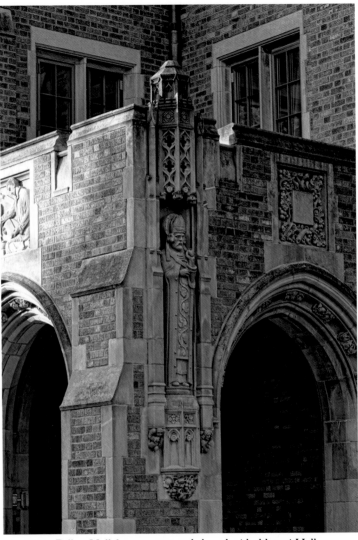

Here you can see the richly decorated entrance to Dillon Hall from a courtyard shared with Alumni Hall. Its sundial marks the hours in the morning. A companion on Alumni Hall marks the afternoon hours.

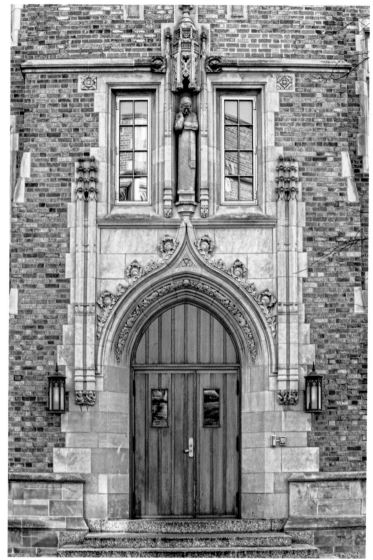

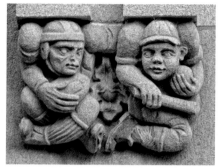

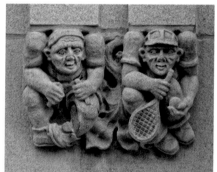

The west door of Dillon Hall, reached by the walkway between Dillon Hall and the South Dining Hall, is graced with reliefs of athletes on each side of the door, while a watchful figure overhead notes those entering and leaving.

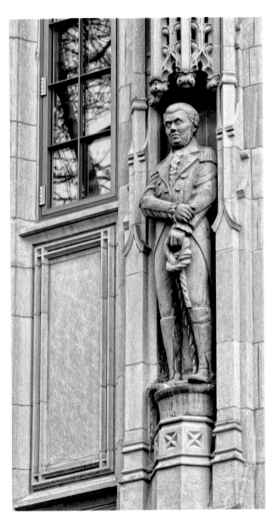

Bas-relief – Dillon Hall

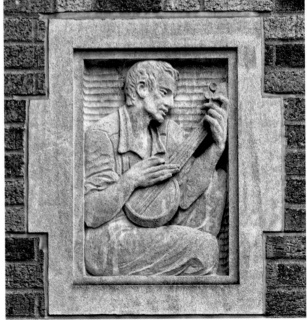

Built in 1924, Howard Hall was the first dormitory constructed, albeit sparingly, in the Collegiate-Gothic style. It has been a residence for women since 1987.

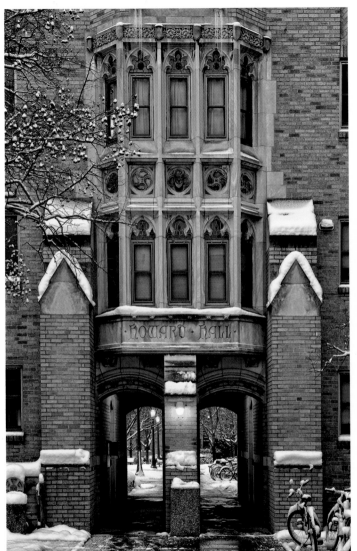

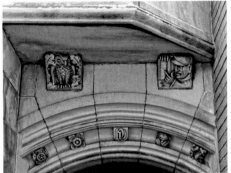
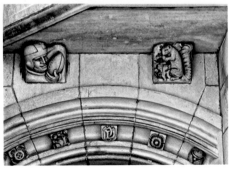

Howard Hall's archway is adorned with bas-relief figures on each side and above the entry. The archway provides a shortcut to Morrissey Hall.

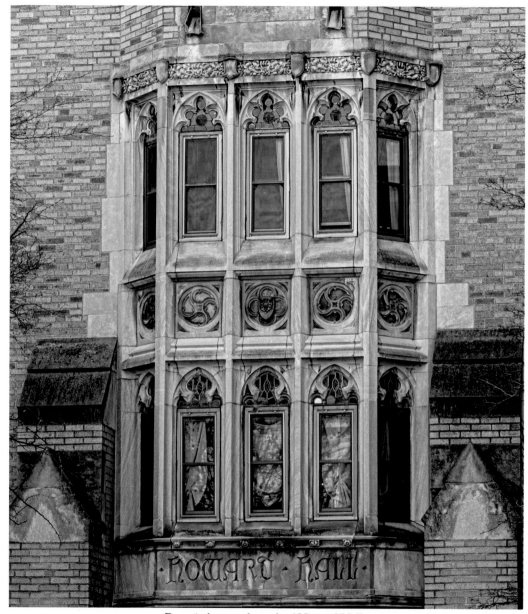

Bay windows at the arch of Howard Hall.

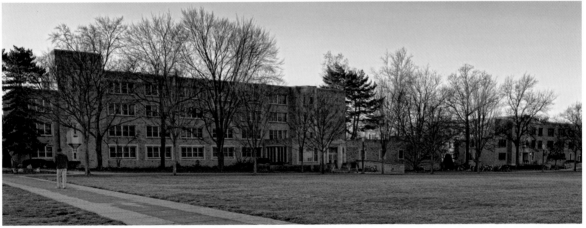

The lower level of Badin Hall, a residence for women, once housed a barber shop and the pickup counter for laundry; the first floor currently holds the Alliance for Catholic Education. Fisher and Pangborn halls were built in the '50s in the same austere, but functional, style of Keenan and Stanford halls, and are devoid of any connection to the Collegiate-Gothic style of the older buildings.

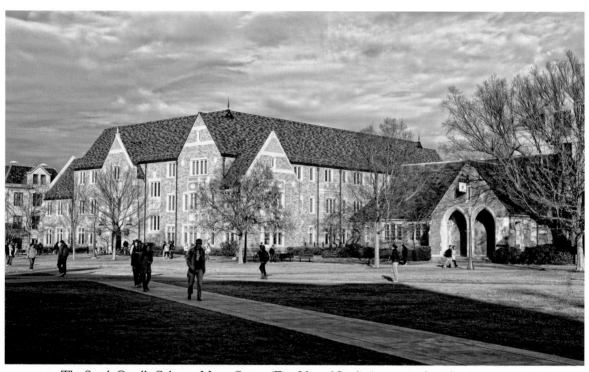

The South Quad's Coleman-Morse Center (First Year of Studies) now stands at the site once occupied by the Hammes Bookstore building—a small structure packed with sweatshirts, textbooks, and a basement-level bowling alley. Today, the smaller building on the east side houses the campus council of the Knights of Columbus, but it was the campus post office until the '70s.

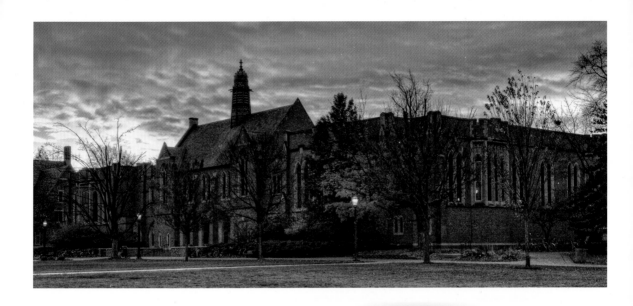

South Dining Hall and Reckers – The east and west wings of the dining hall once housed serving lines for students—a coat and tie were mandatory for the evening meal. Nonetheless, there were occasional food fights protesting for better fare. A public dining area, dubbed the "Oak Room," occupied the central chamber. Now a food court with multiple serving stations in the central chamber serves all students, and the large side halls are the so-called "Harry Potter" dining rooms. Today, with flexible meal plans, students choose freely from a variety of dishes, without limits on their selections.

Reckers is an addition to the south side of the building. Presently, it provides 24-hour light fare, including cheap hotdogs.

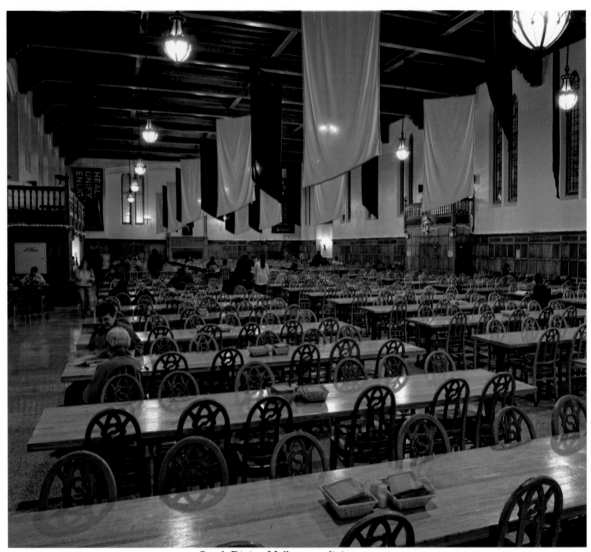

South Dining Hall – west dining room.

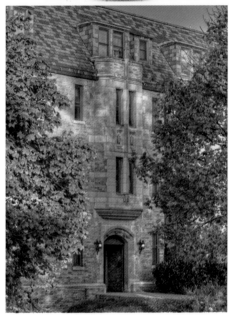

Lyons Hall is named after Professor Joseph Lyons, who came to Notre Dame as an orphaned apprentice shoemaker, graduated with highest honors, and became a professor in the English Department. The arch of Lyons Hall is one of the most photographed icons on campus.

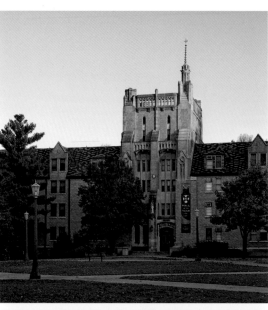

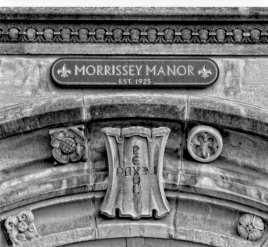

Morrissey Hall's central tower separates its east and west wings. Recent residents have renamed the hall "Morrissey Manor."

Bond Hall housed the University's Lemmonier Library from 1917 until 1963, when the Hesburgh Memorial Library opened. The School of Architecture now occupies the building. The Notre Dame Marching Band performs a concert on the front steps before home football games.

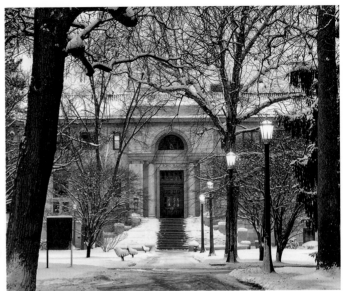

The "old" ROTC Building, located behind the Rockne Memorial, was a major facility for training naval officers during World War II.

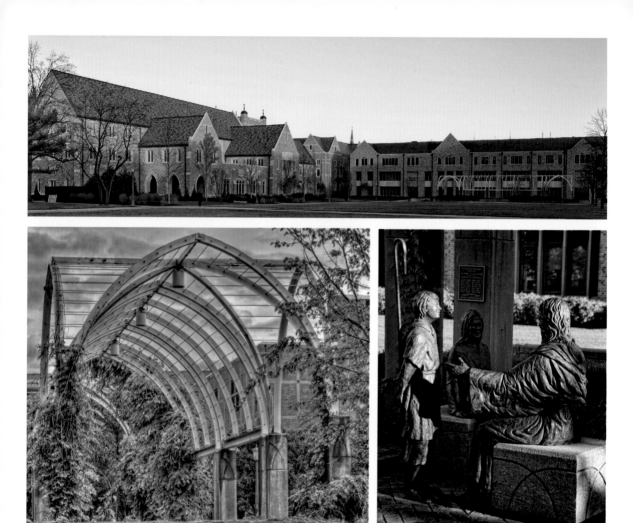

The Eck Hall of Law and the Fitzpatrick Hall of Engineering establish the north boundary of the DeBartolo Quad. The Quad extends southward to the edge of campus to the DeBartolo Performing Arts Center at Angela Blvd., with sides flanked by the newer and more functional academic buildings: DeBartolo Hall, Mendoza College of Business, and Stinson-Remick Hall, as well as the Hesburgh Center for International Studies. The Christ the Teacher sculpture is located in Sesquicentennial Commmons, the vine-covered trellis structure adjacent to Fitzpatrick Hall.

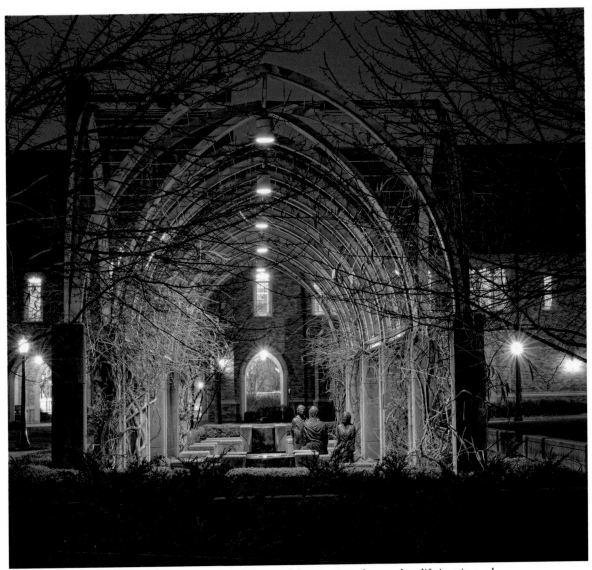

Christ the Teacher – in the wee hours of the morning when student life is at its peak.

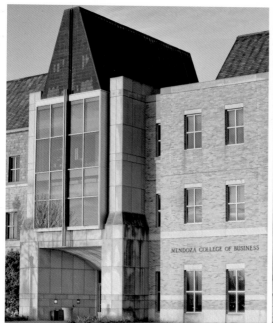

DeBartolo Hall and the buildings of the Mendoza College of Business line the east side of the DeBartolo Quad; Stinson-Remick Hall and the Hesburgh Center for International Studies line the west side along Notre Dame Avenue.

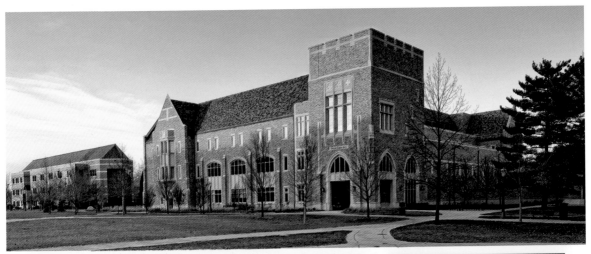

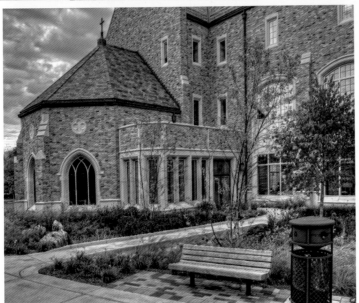

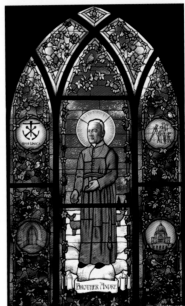

The Hesburgh Center for International Studies, and Stinson-Remick Hall. The Chapel of Stinson-Remick Hall features a stained-glass window depicting Brother André Bessette of the Congregation of Holy Cross (C.S.C.) now Saint André Bessette, C.S.C.

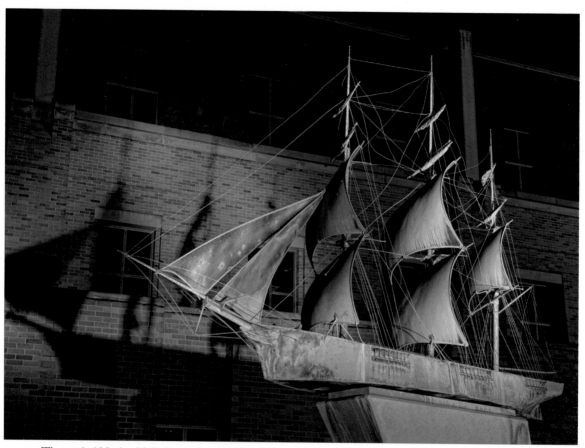

The roof of Hurley Hall, former home of the College of Business Administration (in the South Quad),
was the original home of the trading clipper shown here. It now sits on a pedestal in the courtyard of the
Mendoza College of Business.

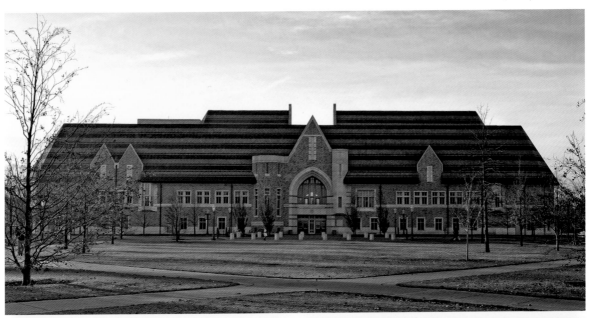

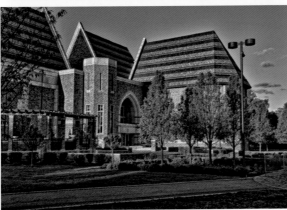

The DeBartolo Performing Arts Center (DPAC), at the south end of the DeBartolo Quad, hosts the cultural life of the campus. DPAC features acoustically and seismically isolated chambers for musical performances, theatre, organ recitals and movies.

Fischer O'Hara-Grace housing for graduate students.

WILSON COMMONS
A LOUNGE AND SOCIAL CENTER
FOR ADVANCED STUDENTS
NAMED
IN HONOR OF
REV. JEROME J. WILSON, C.S.C.
WHO WAS FOR TWENTY-FOUR YEARS
VICE PRESIDENT FOR BUSINESS AFFAIRS
AT THIS UNIVERSITY
1952-1976
IN RECOGNITION AND APPRECIATION OF HIS EFFORTS
IN DEVELOPING HOUSING AND OTHER FACILITIES FOR
ADVANCED STUDENTS AND FOR HIS TOTAL DEDICATION
TO THE UNIVERSITY OF NOTRE DAME.

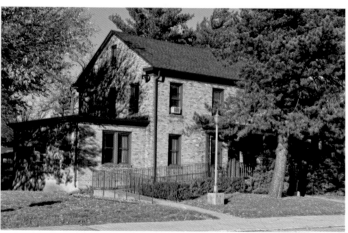

Wilson Commons – a social area and lounge for graduate students.

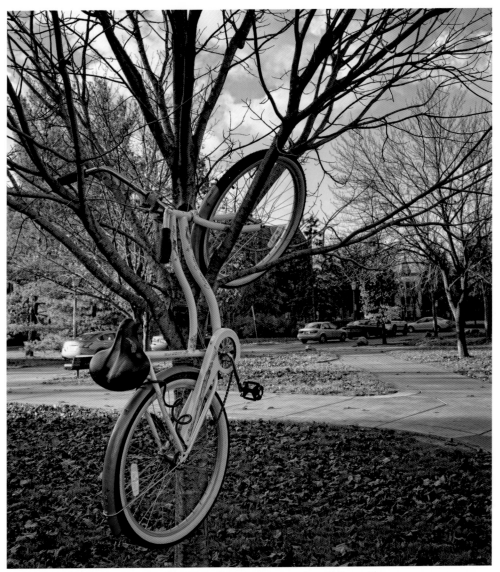

A word to the wise: don't leave bicycles unsecured at a bike rack or at a tree.

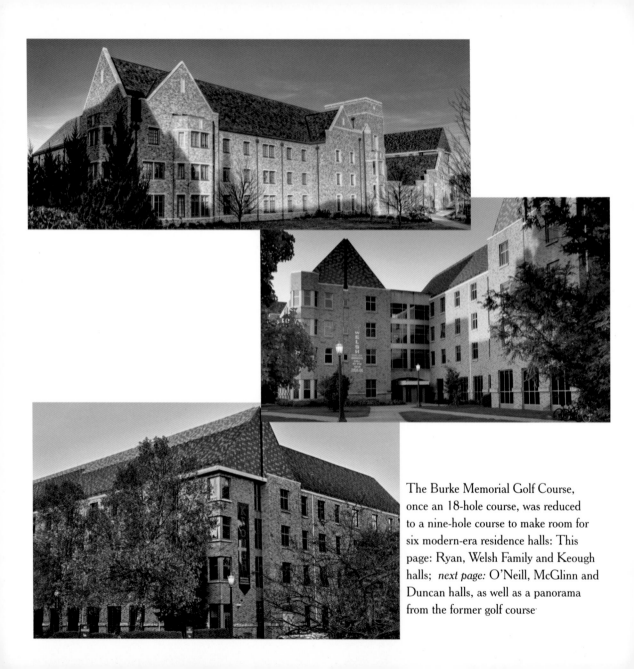

The Burke Memorial Golf Course, once an 18-hole course, was reduced to a nine-hole course to make room for six modern-era residence halls: This page: Ryan, Welsh Family and Keough halls; *next page:* O'Neill, McGlinn and Duncan halls, as well as a panorama from the former golf course.

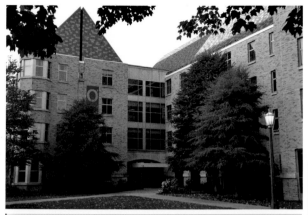

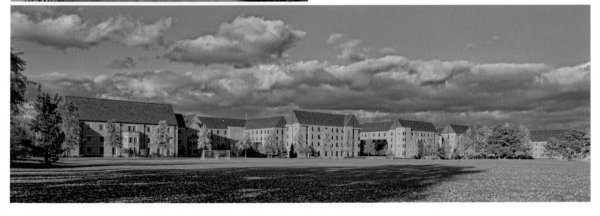

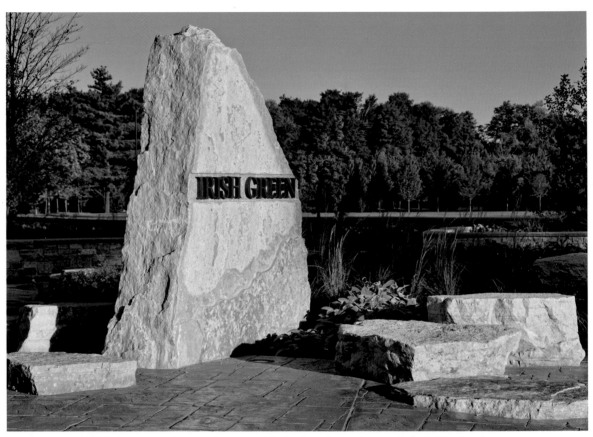

The grassy area immediately south of the DeBartolo Performing Arts Center, bordering Angela Boulevard, has been given the name "Irish Green." The entrance from Eddy Commons has a prominent display marking the site. Pep rallies and pre-game gatherings are held here on football weekends.